THE WHALE

AND OTHER UNCOLLECTED TRANSLATIONS

BOA EDITIONS, LTD.:
NEW AMERICAN TRANSLATION SERIES

THE WHALE

AND OTHER UNCOLLECTED TRANSLATIONS

BY RICHARD WILBUR

BOA EDITIONS, LTD., • BROCKPORT NEW YORK • 1982

Acknowledgments of the previous publication of some of these translations appear on page 54 of this book.

Designed and printed at the Visual Studies Workshop, Rochester, N.Y. Typeset by Open Studio, Rhinebeck, New York;

Publication of this book was made possible with the assistance of a grant from the Literature Program of The New York State Council on the Arts.

ISBN: 0-918526-32-9 Cloth
 0-918526-33-7 Paper
 Library of Congress #82-07163

First Edition: October 1982

BOA Editions, Ltd.
A. Poulin, Jr., Publisher
92 Park Avenue
Brockport, N.Y. 14420

for Charlee

CONTENTS

PREFACE

This is a gathering of translations, written over a period of three decades or more, which for one or another reason were never included in any collection of my poems. Though they are "uncollected" in that sense, I don't present them as leavings. In the case of original work, a poet may with good conscience publish his most vapid orts and scraps, since in so doing he risks no honor but his own. As translator, however, he should hesitate to publish or republish work which he knows to be inadequate, because he owes it to the originals to represent them as well as he can.

I hope I've been fairly scrupulous in choosing the efforts which follow. An attempt upon a poem of Catullus and renderings of several of Nerval's *Chimères* have been suppressed because they were disliked by people whom I respect. One or two of the following are, no doubt, imperfect translations of imperfect originals, which I have preserved because they seemed to me to have some interest: the sonnet from Degas, for example, is interesting in relation to his ballet paintings, and finishes well. A number of these translations — that of Baudelaire's "Albatross," for instance, or those from Brodsky and Vinícius de Moraes — are about as good work as I can do.

I've arranged these translations chronologically within language groupings. The date in brackets generally refers to the translation's first publication, though sometimes to its time of composition.

— *Richard Wilbur*

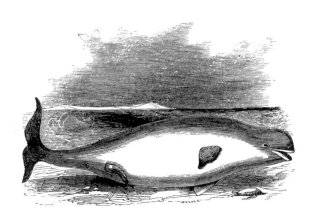

THE WHALE

AND OTHER UNCOLLECTED TRANSLATIONS

"FYRST FORTH GEWAT..."

— from Beowulf

Then the time came when the boat was on the tide,
the ship under the shore-cliffs. Sailors eagerly
flocked to the forecastle. Folded in combers,
sand rolled in seawater. Stowing below
in the bowels of the ship their blazoned armor
and well-made weapons, the warriors shoved out
their hardy vessel on the hoped-for journey.
It went then over the wave-ways, the wind behind it,
the foamy-necked floater, fleet as the sea-gull,
until at the same time of the second day's travel
the curve-prowed craft had compassed the voyage,
so that the seafarers sighted the mainland,
sea-cliffs shining, steep elevations,
high wide headlands; then was the haven found,
the ocean-passage over....

[1948]

BEOWULF'S DEATH-WOUND

— from Beowulf

. . . These words spoken, then came the dragon,
their ugly enemy, in another onslaught;
fire-waves enfolded that foe as it drew near
the waiting warriors. Wiglaf's shield was
burned to the boss, nor would his byrnie
suffice to save him from surges of flame.
Swiftly he sheltered him under the shield of
the king his kinsman (his own consumed in
that blazing breath.) Then King Beowulf,
anxious for honor, with all of his energy
wielded his war-sword, wedging his weapon
in the brow of the dragon. Naegling broke then;
Beowulf's blade, that was battered and grey-hued,
failed him in the fighting. Fate had forbidden
the sharp-edged steel of his sword to serve him
in the bitter battle . . .

Then for a third time, thirsty for carnage,
the fatal firedrake and folk-despoiler,
raging and battle-grim, rushed at the ruler,
forcing him backward; the fire-hot fangs then
breached his gullet; Beowulf's breast
was wet with his lifeblood; it welled out in waves.

[1952]

AN ANGLO-SAXON RIDDLE

— from Exeter Book #46

I saw in a corner something swelling,
Rearing, rising, and raising its cover.
A lovely lady, a lord's daughter,
Buried her hands in that boneless body,
Then covered with a cloth the puffed-up creature.

[1960]

THE SIREN

— *from The Middle English Bestiary*

Strange things indeed Are seen in the sea-world:
Men say that mermaids Are like to maidens
In breast and body, But not so below:
From the navel netherward Nothing looks human,
For there they are fishes And furnished with fins.
These prodigies dwell In a perilous passage
Where swirling waters Swallow men's vessels;
Cheerily they sing In their changeable voices
That are high and sweet And hopeful of harm.
This song makes shipmen Forget their steering
And sink into drowses, And deeply they dream:
For their vessels are sunken, Their voyages over.
But wise men and wary Will turn from these wiles
And often escape That evil embrace,
Being warned of the mermaids. Surely this monster,
Half fish and half woman, Must harbor some meaning.

Signification

Many of mankind Resemble the mermaid;
Without they wear lambskin, Within they are wolves;
Their doctrine is righteous, Their deeds are the Devil's;
Their actions are not In accord with their utterance;
These two-natured creatures Will swear by the cross,
By the sun and the moon, To steer you astray;
With the sweetest of speeches They swindle their fellows;
They will steal both your substance And soul with their falsehood.

[1952]

THE WHALE

— from the Middle English Bestiary

WHALE is the greatest beast In all the ocean waste;
Whom if you ever espied Sprawling upon the tide,
An isle he would seem to be Built on the sands of the sea.

When this fierce fish would feed, He spreads his great mouth wide,
And thence expels his breath, The sweetest smell on earth.
The other fishes come, Ravished by that perfume;
They dawdle within his jaws, Unwary of the ruse.
He slams his jaw-gates then, And drinks those fishes in . . .

This whale-fish dwells secure Down near the ocean floor
Until that season arrives When winter with summer strives
And storm stirs all the sea; In such inclemency
His lair he cannot keep, But up from the troubled deep
He rises, and lies still. Then while the weather is ill,
Sailors driven and tossed Who fear that they are lost,
Sighting the quiet whale, Mistake him for an isle.
They view him with delight And hasten with all their might
To make their vessels fast And climb ashore at last;
With tinder, steel, and stone They kindle a blaze thereon,
Warm them, and drink, and eat. But, feeling the fire's heat,
The whale to sea-deep dives And robs them of their lives.

Signification

The Devil is great in will, With monstrous force and skill
(These powers he imparts To witches in their arts);
He gives men hunger and thirst And many another lust,
Drawing them by his breath, To follow which is death...
Who hears the Devil's word Will rue the day he heard;
Who ties his hopes thereto Will plunge with him below.

[1952]

QUATRAIN

— *François Villon*

France's I am; my lookout's glum.
From Paris (near Pontoise) I come,
And soon my neck, depending from
A rope, will learn the weight of my bum.

[1968]

THE ALBATROSS

— Charles Baudelaire

Often, for pastime, mariners will ensnare
The albatross, that vast sea-bird who sweeps
On high companionable pinion where
Their vessel glides upon the bitter deeps.

Torn from his native space, this captive king
Flounders upon the deck in stricken pride,
And pitiably lets his great white wing
Drag like a heavy paddle at his side.

This rider of winds, how awkward he is, and weak!
How droll he seems, who was all grace of late!
A sailor pokes a pipestem into his beak;
Another, hobbling, mocks his trammeled gait.

The Poet is like this monarch of the clouds,
Familiar of storms, of stars, and of all high things;
Exiled on earth amidst its hooting crowds,
He cannot walk, borne down by giant wings.

[1953]

CORRESPONDENCES

— Charles Baudelaire

Nature is a temple whose living colonnades
Breathe forth a mystic speech in fitful sighs;
Man wanders among symbols in those glades
Where all things watch him with familiar eyes.

Like dwindling echoes gathered far away
Into a deep and thronging unison
Huge as the night or as the light of day,
All scents and sounds and colors meet as one.

Perfumes there are as sweet as the oboe's sound,
Green as the prairies, fresh as a child's caress,
— And there are others, rich, corrupt, profound

And of an infinite pervasiveness,
Like myrrh, or musk, or amber, that excite
The ecstasies of sense, the soul's delight.

[1953]

SONNET V

— Edgar Degas

I think that, sure of the beauty of her repose,
Indolent nature had in the former time
Too dully slept, had grace not often come
With gay and panting voice to bid her rise,

And beaten then for her a pleasing measure,
And with the motion of her speaking hands
And twining of her fiery feet, commanded
That she cavort before her, full of pleasure.

Then come, my darlings, wear that rabble face,
And do not wish for beauty's needless glow!
Leap brazenly, my priestesses of grace!

From the dance you gain a rareness in our eyes,
An air heroic and remote. You know
That queens are made of distance and disguise.

[1949]

LES TRANSPARENTS

— René Char

The Transparents, *or "vagabonds of the sun and moon," have all but vanished now from the towns and woodlands where once they were a common sight. Affable and quick of tongue, they would set down their bindles long enough to hold a dialogue in verse with some native, and then push on. The native, his imagination touched, would present them with bread, wine, salt and raw onions; if it was raining, straw.*

I TOQUEBIOL

The Native

Work, and a town on every side
Shall rise, and every house your own.

Toquebiol

Simplicity, your dream goes down
Before the sickle of my stride.

II LAURENT DE VENASQUE

Laurent is aggrieved. His mistress has not come to the rendezvous where he has been waiting. In vexation, he leaves for good.

Waiting so long,
One loses faith.

Who goes his way
Is not untrue.

Ah, journey, journey:
Little spring.

III PIERRE PRIEURÉ

Pierre

Have you a wish, O night wherein I peer?

Night

That the nightingale be silent,
And the loud impossible love she would lull in her heart.

IV EGLIN AMBROZANE

The Gay Girl

Make ready to be merry,
Stranger, I'll open my door.

Eglin

I am the wolf of sorrow;
Beauty, thy servitor.

V DIANE CANCEL

The Homebody

A roof of well-baked tile,
Walls that arise to arches overhead,
The windows done in the same style,
A wild-cherry Spartan bed
And a looking glass all framed in pirate gold:
There is the Rose with which my heart's consoled.

Diane

But the key that you turn twice

To double lock your patriarchal door
Snuffs out desire, smothers the voice.
On the road's shoulder, when love is done,
 the wind sings me to sleep.

VI RENÉ MAZON

The rock speaks through the lips of René.

I am the cornerstone of God's will, the rock;
His poorest plaything and the least aggressive.

Penetrate me, fig tree:
My looks are a challenge, my depths are a friendliness.

VII JACQUES AIGUILLÉE

Jacques describes himself.

When all the world prays,
We are incredulous.
When no man has faith,
We take up believing.
Like the cat's eye, we alter.

VIII JOSEPH PUISSANTSEIGNEUR

Joseph

Road, art thou there?

The prodigals dwindle together.

IX GUSTAVE CHAMIER

Hear it passing, watch it go by

With your unbending righteous head,
A wisp of the chaff that shall not die.
It's a sad barn that's scorned by bread.

X ÉTIENNE FAGE

I awaken my love,
That it tell me the dawn.

XI AIMERI FAVIER

Aimeri

If you bury me, my friend,
You're burying the wind.

The Gravedigger

Who cares how the wind may fare?

But he dropped his shovel there.

XII LOUIS LE BEL

Louis

Hackers of brambles, ridiculous gardeners,
No doubt you are human, but how you sicken my heart!

The Farmhands

Waster of the sun's gold,
God is our guide, our hearts are satisfied.
What will you answer to that,
Old baby?

Louis

With my heart's help, I'll keep
This road until death's sleep
Shall bring to its conclusion
My freedom from illusion.

XIII JEAN JAUME

I say the olive tree's my twin,
O blue of the air, blue raven feather!

The hills confess they are my kin,
And all day's odors melt together.

XIV COMTE DE SAULT

His epitaph:

To heavy glimmering roses
That the blind hand desires,
Prefer, O passer-by, the eglantine
Whose amorous thorn I am,
Surviving thy effusions.

XV CLAUDE PALUN

The Peasant

Who can believe that death is the end,
Seeing the sheaves shine on a a harvest evening,
And the grain smile as it pours into his hand?

Claude

Our faith goes farther, diligent friend:
Our eternity is of frost.

XVI ALBERT ENSÉNADA

The world in which the Transparents *lived, and which they*
loved, is coming to an end. Albert knows it.

> The loaded gun denies us place,
> The barking of the dogs is done.
> Appear, appear then, shapes of ice;
> Come, *Transparents*, be moving on.

[1956]

FIRE

— Francis Ponge

Fire has several distinct comportments: at first, all the flames steer in one given direction...

(The progression of fire may only be compared to that of animals: it has to leave one spot in order to occupy another; it goes at once like an amoeba and like a giraffe, the neck leaping, the feet crawling...).

Then, as the masses of methodically contaminated matter collapse, the escaping gases are proportionately transformed into a single staircase of butterflies.

[1950]

THE NOTEBOOK OF THE PINE-WOODS

(Extracts)

— Francis Ponge

Here, where a relatively well-ordered profusion of senile masts, topped with verdant domes, is standing; here, where the sun and the wind are sifted by an infinite interweaving of needles; here where the ground is covered by a thick carpet of vegetable hairpins: here is the slow factory of wood. Industrially aligned, but with a majestic slowness, here wood is self-manufactured. It perfects itself in silence, and with a majestic slowness and discretion. With assurance, as well, and with a certainty of success. There are by-products: obscurity, meditation, perfume, etc., faggots of inferior quality, the cones (fruits as tightly clenched as pineapples), vegetable hairneedles, mosses, ferns, bilberries, mushrooms. But throughout all degrees of growing, one falling-off after another, and what-not, the general design is pursued, and darkly foresees itself as staff, as mast: — as beam, as board.

The pine (I should very nearly say) is the rudimentary idea of the tree. It is an I, a trunk, and the rest counts for little. That is why it furnishes — in its obligatory horizontal ramifications — so much dead wood. For the only thing that matters is the trunk, perfectly straight, upthrust, simple, and unwavering from its simple aspiration, remorseless, unrevised, and unrepentant. (In an unrepentant aspiration, perfectly simple, perfectly straight.)

Thus all evolves toward a perfect spareness . . .

·

The pine (especially the pine of the woods) enjoys an annulment of its successive expansions, which happily amends — which reverses — the customary curse of plant existence: the having to bear up eternally under the weight of all one's acts since infancy. More than any other, this tree is privileged to divorce itself from its previous developments. It has leave to forget. It is true that the subsequent growths much resemble the former and outworn ones. But never mind that. What is delightful is to cancel out and begin again. And then, this always happens at a greater and greater height. One feels one has gained something.

[1950]

RAIN

— Francis Ponge

The rain, as I watch it falling into the courtyard, comes down with a great variation of velocities. There in the centre of the yard it is a fine, discontinuous curtain (or net), an implacable but relatively slow fall of what seem to be quite light drops, an everlasting lazy precipitation, an intense segment of pure meteor. Close to the left- and right-hand walls, heavier and more individuated drops are falling with more distinct sound. Here they seem the size of a grain of wheat, there of a pea, elsewhere very nearly that of a marble. On the rods and railings of the window the rain travels horizontally, while on the lower sides of the same obstacles it dangles in gumdrops. Over the whole surface of a small zinc roof which my vantage overlooks, it streams in a very thin sheet, which is moiréd by the very different currents produced by the imperceptible undulations and bumps of the metal. From the adjoining gutter, where it flows with the contentiousness of a deep and nearly level brook, it falls suddenly in a perfectly vertical rope, rather coarsely braided, to the ground, where it shatters and flashes in shining needles.

Each of its forms has a particular behaviour and appearance; for each there is a corresponding particular noise. The whole exists intensely like some complicated mechanism, both precise and fortuitous, like a watch-works whose spring consists in the gravitation of a given mass of precipitating vapour.

The chiming of the vertical threads upon the ground, the gurgling of the gutters, the tiny gong-sounds multiply, and all join together in a concert not monotonous, and not without delicacy.

After the decompression of the spring, certain bits of mechanism continue to function for a time, decelerating more and more, until all the machinery stops. Then if the sun reappears all vanishes very soon; the brilliant apparatus evaporates: we have been showered with pleasure.

[1950]

FAUNA AND FLORA

— Francis Ponge

Fauna move about, whereas flora unfold themselves to the eye.

The ground has taken directly upon itself a whole class of animated creatures.

Their position in the world is assured, and, by right of seniority, their decorations.

Differing in this respect from their vagabond fellows, they are not superadded to the earth, intruders upon the ground. They need not wander seeking a place to die, though the earth carefully consumes their remains, as those of others.

No need for them to worry about provisions or shelter; in their societies, no dog-eat-dog: no terrors, nor wild running, no cruelties, lamentations, cries, words. They are no abettors of restlessness, confusion and murder.

From the moment they see the light, they have settled down. Perfectly unconcerned about their neighbours, they do not enter into each others' lives by means of mutual consumption. They do not issue from each other by gestation.

They die by desiccation and falling to the ground, or rather by sinking in their tracks; rarely by rotting. No area of their bodies is peculiarly sensitive, to the degree that, were it wounded, it would cause the death of the whole individual. Their sensibility, however, is by comparison more subtly susceptible to the climate, to the conditions of existence.

They are not... They are not...

Their hell is of another sort.

They have no voices. They are all but paralytic. They can attract attention only by their postures. They do not give the impression of knowing the pain of not being able to justify themselves. But they could in no manner escape by flight from

that obsession, did they have it; or even think to escape it, in the intoxication of speed. They are capable of no movement save extension. They know no gesture, no thought, perhaps no desire or intention, which does not culminate in a monstrous enlargement of their bodies, in an irremediable *excrescence*.

Or rather, what is very much worse, they are unhappily incapable of monstrosity: despite all their efforts to "express themselves," they never succeed in doing more than repeating the same expression, the same leaf, a million times over. When, in the spring, weary of constraint and no longer able to bear it, they give vent to a flood, an explosion of green, and think to break into an altered chant, to get out of themselves, to stretch out to all nature and embrace it, they will succeed only in producing, thousands of times reduplicated, the same note, the same word, the same leaf.

The tree may not be escaped from by means of the tree.

.

"They express themselves solely by their postures."

No gestures, only the multiplication of their arms, their hands, their fingers — like Buddhas. And so, indolently, they follow their thoughts out to the end. They are nothing but a will to expression. They hold nothing hidden and to themselves, they are unable to keep secret a single idea, they display themselves entirely, honestly, unreservedly.

Being indolent, they spend their days in complicating their own shapes, in pushing to the limit — in the direction of the greatest possible analytical complexity — their own bodies. Wherever they are born, however hidden they may be, they concern themselves only with the achievement of their self-expression: they dispose themselves, they adorn themselves, they wait for someone to come and read them.

For the purpose of attracting attention, they have at their disposal only their postures, their lines, and occasionally an exceptional signal, an extraordinary appeal to the eye and the sense of smell, in the shape of bulbs or luminous and odorous balls, which are said to be their flowers, but are probably wounds.

This modification of the everlasting leaf surely must signify something.

.

Time among the plants: they seem always frozen, immobile. One turns one's back for a few days, for a week, and their postures are all the more definite, while their members have multiplied. Of their identities there is never any question, but their forms are constantly more and more fulfilled.

.

The beauty of fading flowers: the petals twist as if under the effect of fire: and of course that's what it really is: a dehydration. They twist so as to expose the seeds to whom they now decide to give their chance, to whom they leave the field free.

This is the season when nature confronts the flower, forcing it to lay itself open to change, to discard itself: it shrivels up, and twists, it shrinks, and gives the victory to the seed which it has made ready, and which emerges from it.

.

Time among the plants is expressed in terms of space, in the space which the plants occupy little by little, filling out patterns which are probably forever determined...

Like the development of crystals: a will to formation, coupled with an absolute inability to form oneself in any other fashion but the *one*.

.

Among living beings one may make a distinction between those in whom, in addition to the movement which makes them grow, there operates a force whereby they may move all, or some part, of their bodies, and each in his own way move about in the world — and those in whom there is no other movement than extension.

Once free of the obligation to grow, the first *express themselves* in various fashions, in regard to the thousand problems of shelter and food and defence, and finally — once they have achieved a certain degree of security — in certain pastimes.

Of the second class, who are not confronted with these pressing necessities, one cannot say that they have no other urge or purpose than to increase in size, but in any case, whatever wishes for expression they may possess are powerless to accomplish anything, unless it is the development of their own bodies — as if each of one's desires were to cost one the obligation thenceforward to nourish and support an additional member. An infernal multiplication of one's substance, occasioned by the slightest thought! Each dream of flight adds another link to my heavy chain!

·

The plant is an analysis in action, a peculiar dialectic in space. Development by the subdivision of the preceding operation. Among animals, expression is oral, or is pantomimed by gestures which cancel one another out. But the self-expression of vegetable life is a written thing, and once done it is done. No chance of going back and changing it, no possibility of revisions or repentances: in order to correct, one must append. Like correcting an essay already written, and which has already *appeared*, by means of appendices, and so on. However, it must be added that plants cannot infinitely subdivide themselves. For each one there is a set limit.

Each one of their movements leaves not only a mark, as do men in writing, but leaves also a presence, something irremediably begotten, and *not separate from themselves.*

●

Their postures, or "tableaux-vivants":
mute entreaties, supplications, unruffled strength, triumphs.

●

They say the crippled and the amputated find that their faculties develop prodigiously: likewise the plants: to their immobility they owe their perfection, their intricate profusion, their lovely decorations, their rich fruits.

●

Not a single gesture, out of all their actions, has any effect outside themselves.

●

Their immobility has translated the infinite variety of feelings generated by desire into the infinite diversity of their forms.

●

A set of the most extremely complicated laws, that is to say the most absolute chance, governs the birth of plants, and their placement upon the surface of the globe.
The law of *indeterminate determinants.*

●

Plants at night.

The exhalation of carbonic acid by the reaction of the chlorophyll, is as a sigh of satisfaction lasting for hours, or as if the lowest string of all the stringed instruments, slackened as far as possible, vibrated at the very limits of music, of pure sound, and of silence.

·

ALTHOUGH THE VEGETABLE BEING HAD RATHER BE DEFINED BY ITS CONTOURS AND BY ITS FORMS, I SHALL FIRST PAY IT HONOUR FOR A VIRTUE PERTAINING TO ITS SUBSTANCE: THAT OF BEING ABLE TO ACCOMPLISH ITS OWN SYNTHESIS AT THE EXPENSE OF NOTHING BUT THE INORGANIC ENVIRONMENT WHICH SURROUNDS IT. ALL THE WORLD ABOUT IT IS BUT A MINE WHENCE THE PRECIOUS GREEN VEIN BORROWS WHAT IT NEEDS FOR THE CONTINUAL ELABORATION OF ITS PROTOPLASM, DRAWING FROM THE AIR BY THE PHOTOSYNTHETIC FUNCTION OF ITS LEAVES, FROM THE EARTH BY THE ABSORBENT ACTION OF ITS ROOTS IN THE ASSIMILATION OF MINERAL SALTS. THENCE COMES THE ESSENTIAL CHARACTER OF THIS BEING, FREED OF DOMICILIARY WORRIES, AND OF ALIMENTARY CARES AS WELL, BY THE PRESENCE ABOUT IT OF AN INFINITE SOURCE OF SUSTENANCE: *Immobility*.

[1950]

APOEM I

— *Henri Pichette*

Men, remember the marches and the halts.
Men, with our throats afire, we drank at fountains.
Men leaning from trains, you were carried away.
Men I see you again bestowing red roses.
Men, my delicate ones, you were killers of birds.
Men indiscriminate, vigil-worn.
Men come down the river, standing on barges...
Place your bets again, the barkers shouted.
The hard-spun wheels, like drunken heliotropes,
Uttered a crazy rattle sound. The light
Inspired the players there enough to make
Their lips appear to whisper golden words.
Some cried : *I'm staking all on liberty.*
They had to break through cordons of police.
Naked men, still you come in indian file:
Dockers, coolies, negroes pounding tom-toms,
Americans out of work, Arabian drovers,
Painted Iroquois on gentled mustangs...
Men whose fingers thrust among golden grapes,
Men nestled in hay, and such dark men,
You who explore the chimneys; men then
Of the open air; men hailing St. Elmo's fire:
Men from nowhere, knowing several tongues;
Hawkers, bakers, pavers, anchorites;
Men! Angels! Devils! I name you. Then...

Then was the stainless season of grains and cornflowers,
Orgy of ideal existence. After which
The laundresses upon their knees were swatting
Founders' denims, lovers' silks, the smocks
Of schoolboys, heavy sheets. Their hands anointed
With the holy oil of the river, they went away.
Along the roads, come night, the chilly gods,
Their faces cut in two by the shine of the moon,
Drank from their cold gourds to restore their colour.
Then winter dropped like a marvelous white drum.
The symphony? is only a matter of patience,
People said. And the stripped trees rustled:
Where is the dormouse hiding? They remembered
Desperate cases: the wounded hind, the tomtit
Limed, the moth in the fingers of a girl in love,
The bee drowning inside the stoppered bottle.
Well, the dormouse was dozing. *There's a whole poem in that.*
More than once the slow organs of clouds
Passed over . . . Dogged workers, then you paused
In your labour to listen! — all except the blacksmiths . . .
The schoolboys left their game. And the wheedling snow
Hushed the countries where the trees are angels.
But one night the snowslide strangles our villages.
Word goes round that death has cast his lasso.
The stars rough-house. The chamois are no more
Than plumblines snapping. Heaven like a propeller
Lops off the eagle's head. *It is going to rain.*
Blood spurts, day settles among the stones.

We'll say that they have died for the Fatherland.
Poetry, having escaped, goes raving, while
The rescuers wipe themselves. The mad are afraid.
The jaded mountain sleeps with open eyes.
And peace on skis goes railing after dreams . . .
Thus did the organs change to barricades.
They lynched the anemone and slew clear water.
The men fell in love with *wordless women.*
They dodged danger as birds avoid a cat.
The life they wore was radiant as crystal . . .
Love shall no longer hibernate. Hey, rioters,
Off with your capes and bash out all the lamps
(The hushed lamps of the evening insult you).
The sky hatches knives. The riot swells.
We'll butcher God. The soul swims in alcohol.
And now a cannon hurls the sun aloft.
The people hide their eyes. *It's mad, stark mad.*
The sotted sun is fouled in quivering aspens
And bleeds till Eastertide upon the cherries.
Our workers are astonished by this marvel.
Fine day. Their words are full of Candlemas.
The revolt opens, as Christ when he was nailed.
The dynamited lemons of dawn are bursting.
The seasons hammer. *I no more remember.*

[1948]

TO. R. N. RIKOV-GUKOVSKI
(1922)

— Anna Akhmatova

All is despoiled, abandoned, sold;
Death's wing has swept the sky of color;
All's eaten by a hungry dolor.
What is this light which we behold?

Odors of cherry blossom sigh
From the rumored forest beyond the town.
At night, new constellations crown
The high, clear heavens of July.

Closer it comes, and closer still,
To houses ruinous and blind:
Some marvelous thing still undivined,
Some fiat of the century's will.

[1961]

PROCESSION WITH THE MADONNA

— Yevgeny Yevtushenko

In the small, untroubled town of Taormina
A grave procession passed with its Madonna.
Smoke from the candles rose and came to nothing,
As frail as any moment's brief enigma.

There in the forefront, all attired in white,
The young girls walked, holding their candles tightly.
Flushed with a timid rapture, on they came,
Full of themselves and of the world's delight.

And the girls stared at the candles in their hands,
And in those flames, unstable in the wind,
They saw stupendous meetings, deep communions,
And heard endearments past all understanding.

Oh, it was right that the young girls should be hopeful.
The hour of their deception was not yet ripe.
But there behind them, like their fates impending,
The women marched along with weary step.

Attired in black, the women marched along,
And they too held their candles tightly, strongly,
Heavily shuffling, grave and undeceived,
And full of an accustomed sense of wrong.

And the women stared at the candles in their hands,
And in those flames, unstable in the wind,
They saw the scrawny shoulders of their children
And heard the vacant speeches of their husbands.

Thus, street by street, they all went on together,
Declaring that the Madonna was their mother,
And bearing the Madonna like some strange
Victim who stands erect upon her stretcher.

The Madonna's heart, or so it appeared, was pained
Both for the girls and for the women behind them;
And yet — or so it appeared — she had decreed
That life go on like this, world without end.

I walked beside the Madonna, and my glance
Found in the candles no glad radiance,
No weary sorrow, but a muddled vision
Full of sweet hope and bitterness at once.

And so I live — still dreaming, still unmarried,
And yet already doomed forevermore —
Somewhere between the girls in their white dresses
And the grey women in their black attire.

Sicily
[1971]

SIX YEARS LATER

— Joseph Brodsky

So long had life together been that now
The second of January fell again
On Tuesday, making her astonished brow
Lift like a windshield-wiper in the rain,
 So that her misty sadness cleared, and showed
 A cloudless distance waiting up the road.

So long had life together been that once
The snow began to fall, it seemed unending;
That, lest the flakes should make her eyelids wince,
I'd shield them with my hand, and they, pretending
 Not to believe that cherishing of eyes
 Would beat against my palm like butterflies.

So alien had all novelty become
That sleep's entanglements would put to shame
Whatever depths the analysts might plumb;
That when my lips blew out the candle-flame,
 Her lips, fluttering from my shoulder, sought
 To join my own, without another thought.

So long had life together been, that all
That tattered brood of papered roses went,
And a whole birch-grove grew upon the wall,
And we had money, by some accident,
 And tonguelike on the sea, for thirty days,
 The sunset threatened Turkey with its blaze.

So long had life together been without
Books, chairs, utensils — only that ancient bed,
That the triangle, before it came about,
Had been a perpendicular, the head
 Of some acquaintance hovering above
 Two points which had been coalesced by love.

So long had life together been that she
And I, with our joint shadows, had composed
A double door, a door which even if we
Were lost in work or sleep, was always closed:
 Somehow, it would appear, we drifted right
 On through it into the future, into the night.

[1974]

MR. T. S. ELIOT COOKING PASTA

— Jósef Tornai

That crackle is well worth hearing.
He breaks in two the macaroni tubes
So as to make them fit the pot,
Then casts them with both hands into the water
Above the white electric range.
The water bubbles, seethes, the *pasta*
Sinks to the bottom of the pot.
Mr. Eliot casts a glance
Through the wide kitchen window toward the park:
it is raining there, and water
pours down the trunks of trees in substantial quantity,
tousling the lawn into a poison-green
Sargasso Sea.
Which reminds him of the pot.
Just so much contemplation has sufficed
For the rising of the *pasta*
to the water's surface.
He fishes out the bouncing ropes
with a colander, American-made,
and runs cold water on them from the tap.
"One is obliged to do so, otherwise
they will stick together." So Mr. Eliot writes
to a friend, later that evening.
"Still, the most gripping moment
comes when the macaroni
are broken in two with a dry crackle:
in that, somehow,
one recognizes oneself."

[1977]

SELF-PORTRAIT AT THIRTY

— Miklós Veress

In his sockets there were eyeballs full of thirst
and there were pockmarks three upon his brow
but not such leanness in the face since now
alas his empty cup had dropped and burst:

he smiled at moments hesitant and quaint
and when he had consoled some fellow-being
he stared disconsolate in the mirror seeing
poor Don Quixote on his poor old Paint

wearing what seemed a sword-inflicted gash
in the back — memento of a drawn-out clash
and private war in which his youth had died

and all sad wines been emptied to the lees
and trampled down all noble mysteries
leaving a surf of silence deep inside.

[1977]

WEIGHTLESS NOW

— Giuseppe Ungaretti

For a God who is laughing like a child
So many cries of sparrows,
So many hoppings high in the branches,

A soul grows weightless now,
Such tenderness is on the fields,
Such chastity refills the eyes,

The hands like leaves
Float breathless in the air . . .

Who fears, who judges now?

[1970]

RONDEAU OF THE LITTLE HORSES

— Manuel Bandeira

The little horses trotting
While we're horsing around and eating...
Your beauty, Esmeralda,
Became intoxicating.

The little horses trotting
While we're horsing around and eating...
The sun out there so brilliant
That in my soul — is setting!

The little horses trotting
While we're horsing around and eating...
Alfonso Reyes departing
And all the rest still sitting...

The little horses trotting
While we're horsing around and eating...
Italy shouting defiance
And Europe afraid of fighting...

The little horses trotting
While we're horsing around and eating...
Brazil orating, debating,
Poetry dead and rotting...
The sun out there so brilliant,
The bright sun, Esmeralda,
That in my soul — is setting!

[1972]

SONG

— Vinícius de Moraes

Never take her away,
The daughter whom you gave me,
The gentle, moist, untroubled
Small daughter whom you gave me;
O let her heavenly babbling
Beset me and enslave me.
Don't take her; let her stay,
Beset my heart, and win me,
That I may put away
The firstborn child within me,
That cold, petrific, dry
Daughter whom death once gave,
Whose life is a long cry
For milk she may not have,
And who, in the night-time, calls me
In the saddest voice that can be
Father, Father, and tells me
Of the love she feels for me.
Don't let her go away,
Her whom you gave — my daughter —
Lest I should come to favor
That wilder one, that other
Who does not leave me ever.

[1972]

Grateful acknowledgment is made to the editors and publishers of the following publications in which some of these translations, or earlier versions of them, first appeared:

"Fyrst forth gewat..." and "Beowulf's Death-Wound": *Wake*, 1948;

"The Siren" and "The Whale" (originally entitled "The Nature of the Siren" and "The Nature of the Whale") from *A Bestiary*, compiled by Richard Wilbur. Illustrated by Alexander Calder. Copyright © 1955 by Random House, Inc. Reprinted with the permission of Random House, Inc.;

"The Albatross" and "Correspondences" by Charles Baudelaire from *The Flowers of Evil*, Marthiel and Jackson Mathews, editors. Copyright © 1955 by New Directions Publishing Corporation. Reprinted with the permission of New Directions Publishing Corporation;

"Sonnet V" by Edgar Degas: *Transition Forty-Nine*, 1949;

"Les Transparents" by René Char from *Hypnos Waking: Poetry & Prose of René Char*, Translated by Jackson Mathews & Others. Copyright © 1955 by Random House, Inc. Reprinted with the permission of Random House, Inc.;

"Fire," extracts from "The Notebooks of the Pine-Woods," "Rain" and "Fauna and Flora" by Francis Ponge: *Transition Fifty*, 1950;

"Apoem I" by Henri Pichette: *Transition Forty-Eight*, 1948;

"To N. V. Rikov-Gukovski" by Anna Akhmatova from *Poets on Street Corners* by Olga Carlisle. Copyright © 1968 by Random House, Inc. Reprinted with the permission of Random House, Inc.;

"Procession with the Madonna" by Yevgeny Yevtushenko, translated by Richard Wilbur with Anthony Kahn, copyright © 1971 by Doubleday & Co., Inc.;

"Six Years Later" by Joseph Brodsky from *A Part of Speech* by Joseph Brodsky, copyright © 1978 by Farrar, Straus & Giroux, Inc. and first published in *The New Yorker*. Reprinted with the permission of Farrar, Straus & Giroux, Inc.;

"Mr. T. S. Eliot Cooking Pasta" by Joséf Tornai and "Self-Portrait at Thirty" by Miklós Veress" from *Modern Hungarian Poetry*. Reprinted with the permission of Columbia University Press and The Translation Center of Columbia University;

"Weightless Snow" by Giuseppi Ungaretti from *Translations by American Poets*, Jean Garrigue, editor. Copright © 1970 by Ohio University Press. Reprinted with the permission of The Academy of American Poets;

"Rondeau of the Little Horses" by Manuel Bandeira and "Song" by Vinícius de Moraes from *An Anthology of Twentieth-Century Brazilian Poetry*, Bishop and Brasil, editors. Copyright © 1972 by Wesleyan University Press. Reprinted with the permission of Wesleyan University Press.